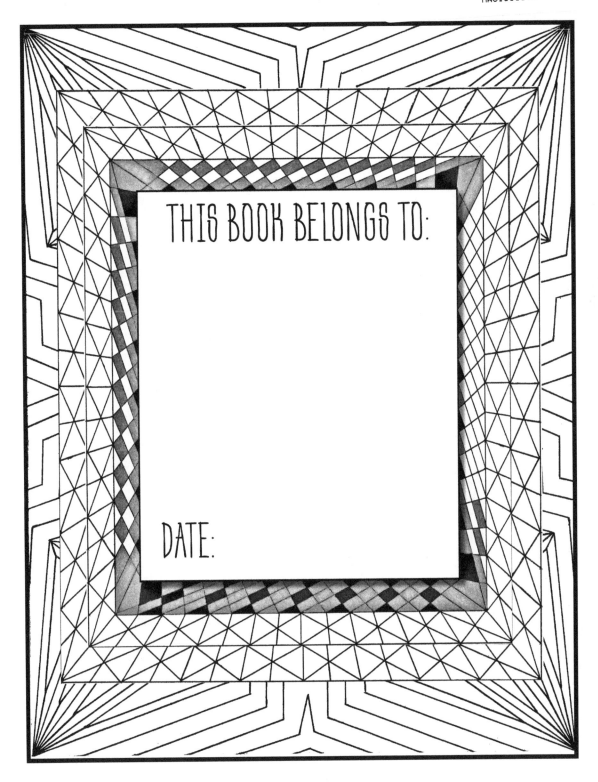

# Color Me Hopeful!

Hope matters. Hope is a choice. Hope can be learned. Hope can be shared with others.
- Shane J. Lopez

INSPIRATIONAL COLORING - HOPE EDITION is an inspirational Teen & Adult Coloring book with hand-drawn designs and life encouraging quotes on every page. With the world of computer imaging, hand-drawn designs have the ability to touch the human soul. Sometimes we need something a little more genuine, something a little more real and authentic! There is no substitute for the human hand.

With Hope Dealer Designs we offer authentic original designs from different artists that have taken hundreds of hours to create these hand-drawn designs within our coloring book series with different themed editions. As you add your own splash of creativity to these hand-drawn images and notice subtle variations and imperfections, please know that a Hope Dealer somewhere created these pages with a heart for giving hope.

* A portion of all proceeds from our products goes to support other charitable organizations and causes that help real people, other Hope Dealers. So, you not only color your heart hopeful, you also help color your world hopeful. NOW, HOW AWESOME IS THAT!

## WHO DOESN'T LOVE MORE HOPE

Reduce Stress - Improve Motor Skills - Improve Sleep - Improve Focus
Improve Vision - Release Good Chemicals in the Brain - Relax the Brain

As you color your way through these amazing designs and meditate on the Hope Statements on each page, my prayer is that you too will discover the power of hope and start to allow your heart to be filled with encouragement.

During my last 20 years of life, after seeking counseling to find healing from trauma, depression, anxiety... and going through trials as a small business entreprenuer & in ministry, I have seen my share of situations that looked utterly hopeless. I persevered to discover the power of hope and now aspire to share that inspiration with others. I have walked with those battling cancer, divorce, addictions, PTSD, the incarcerated... Today, some of these very people are the very ones that have hand-crafted the following pages. They are the true Hope Dealers!

*Holly Oden*
Mrs. Nationwide 2021

This book is dedicated to my mom, Jo Ann (my hero), who bravely lost her battle to ovarian cancer in 2020.

## MY HERO FOR THE DAY

I looked around for a hero and came up with a big zero.
I asked God, "What is wrong? I'm just not that strong."
His reply, "Maybe you have looked too far. Maybe it's someone dressed in armour and shining like a star."
There she was, my daughter Holly, whom I adore.
Please be my hero for the day. Love Mom

Hope is belief that the future will be better than the present, along with the belief that you have the power to make it so.

- Shane J. Lopez

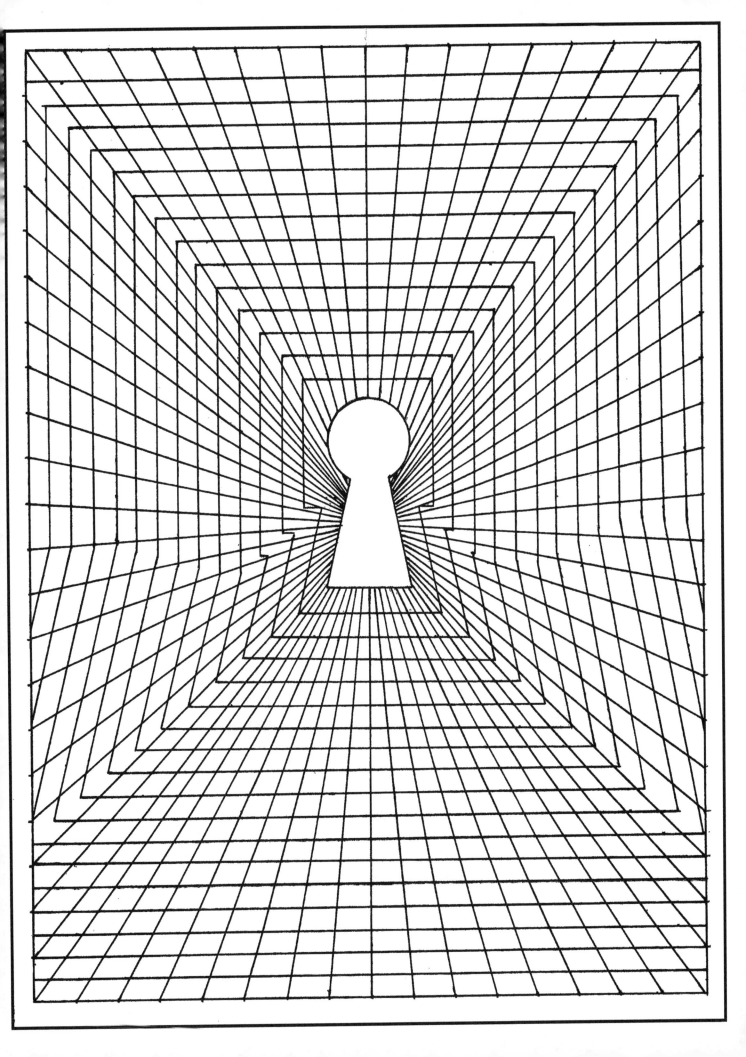

Hope is a thought "insurance policy" that can help you move through challenges and deal with hard times.

- Dr. Caroline Leaf

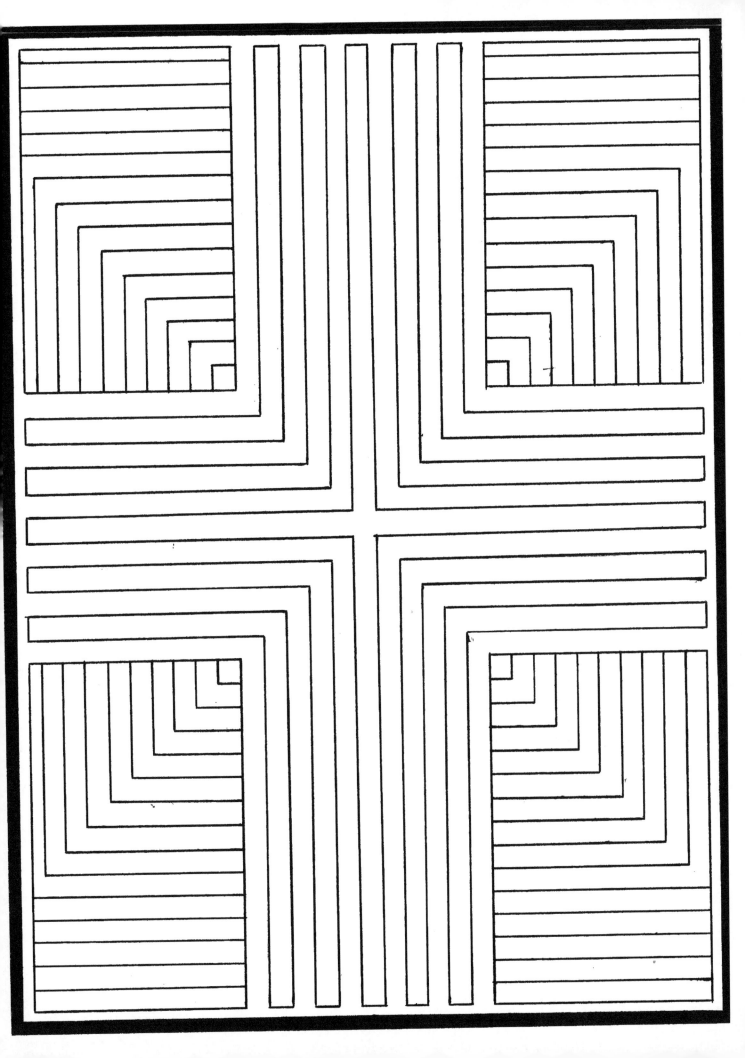

How we think about the future--how we hope--determines how well we live our lives.

- Shane J. Lopez

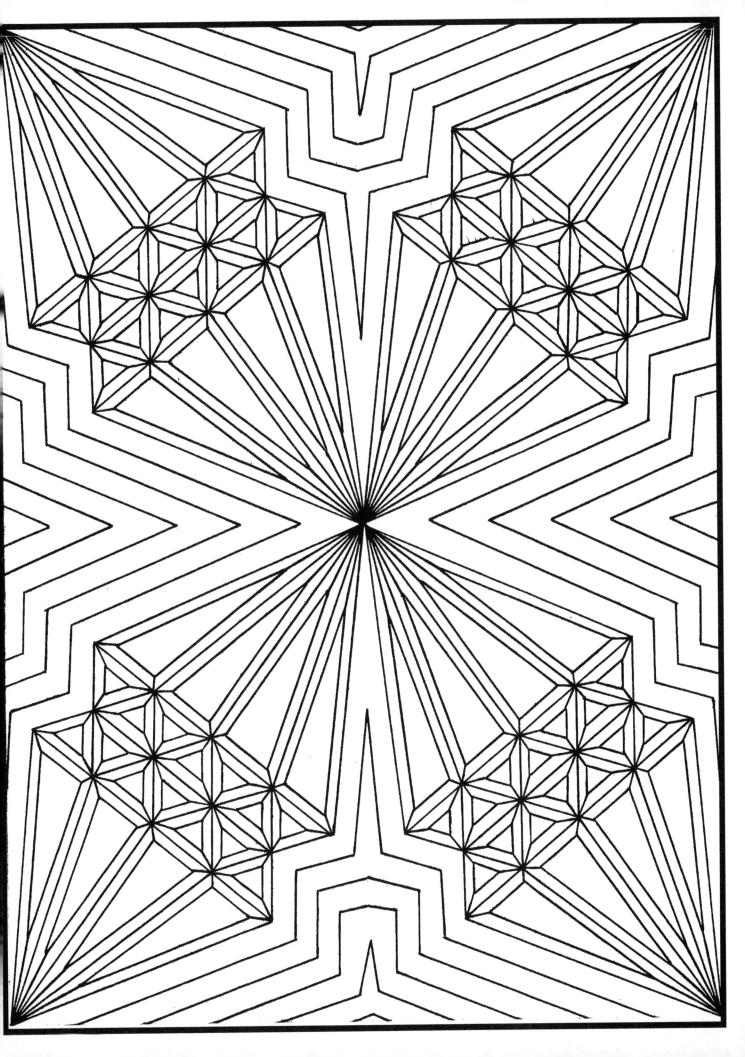

Don't lose heart. Don't lose hope. Don't lose faith. Don't lose patience. Keep asking. Keep seeking. Keep knocking.

- Mark Batterson

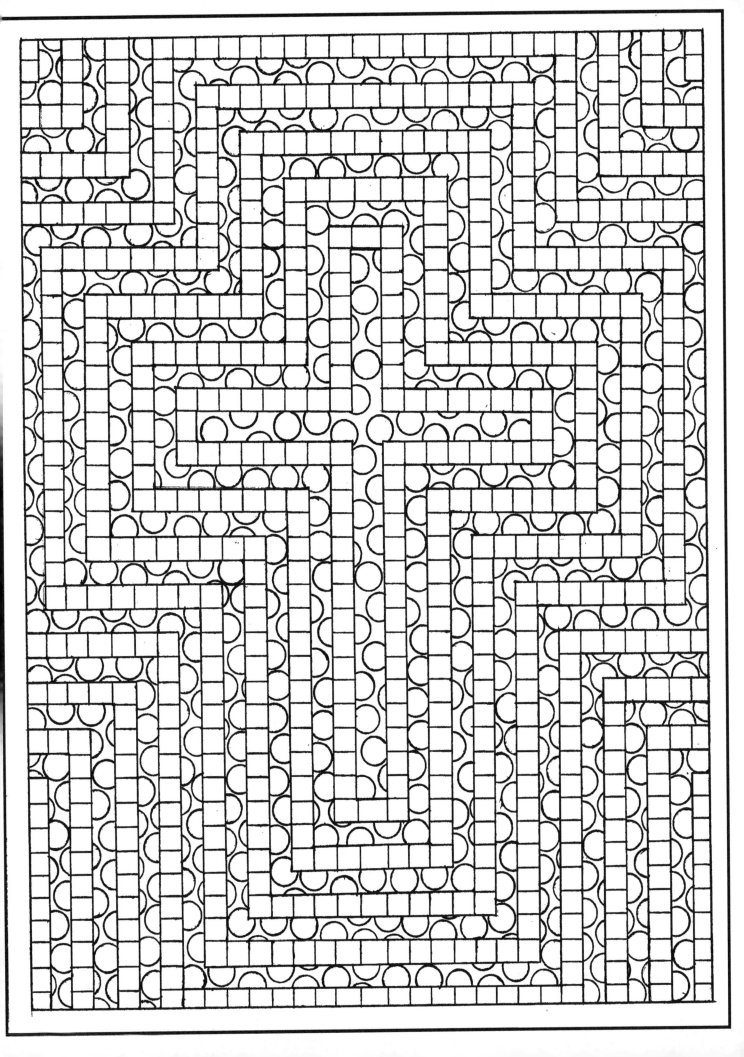

You cannot sit back and wait to be happy and healthy and just have a great thought life; you have to make the choice to make this happen.

- Dr. Caroline Leaf

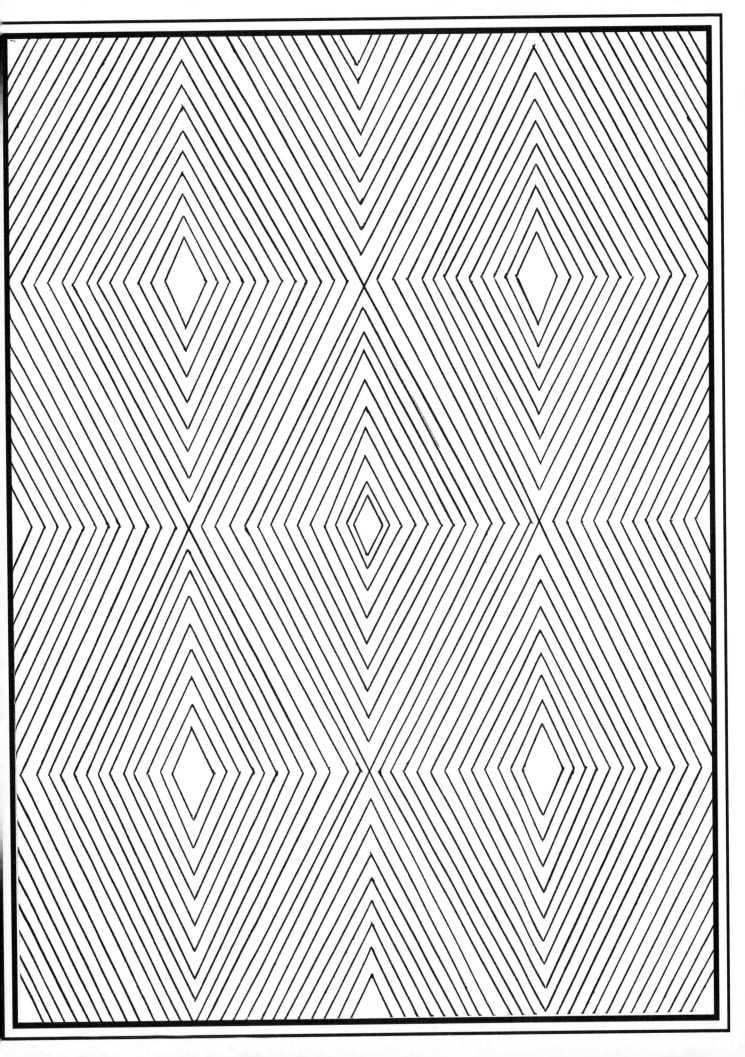

Hope is being able to see that there is ight despite all of the darkness.

- Desmond Tutu

Hope is favorable and confident expectation; it's an expectant attitude that something good is going to happen and things will work out.

- Joyce Meyer

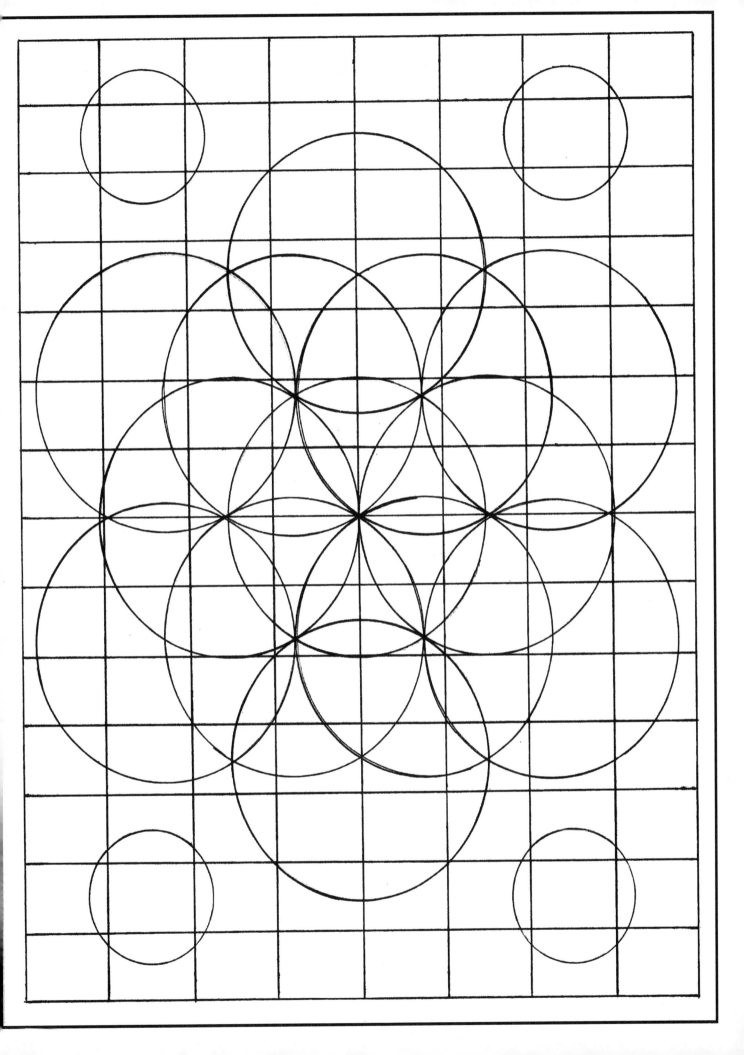

The new dawn blooms as we free it. For there is always light if only we're brave enough to see it, if only we're brave enough to be it.

- National Youth Poet L. A. Gorman

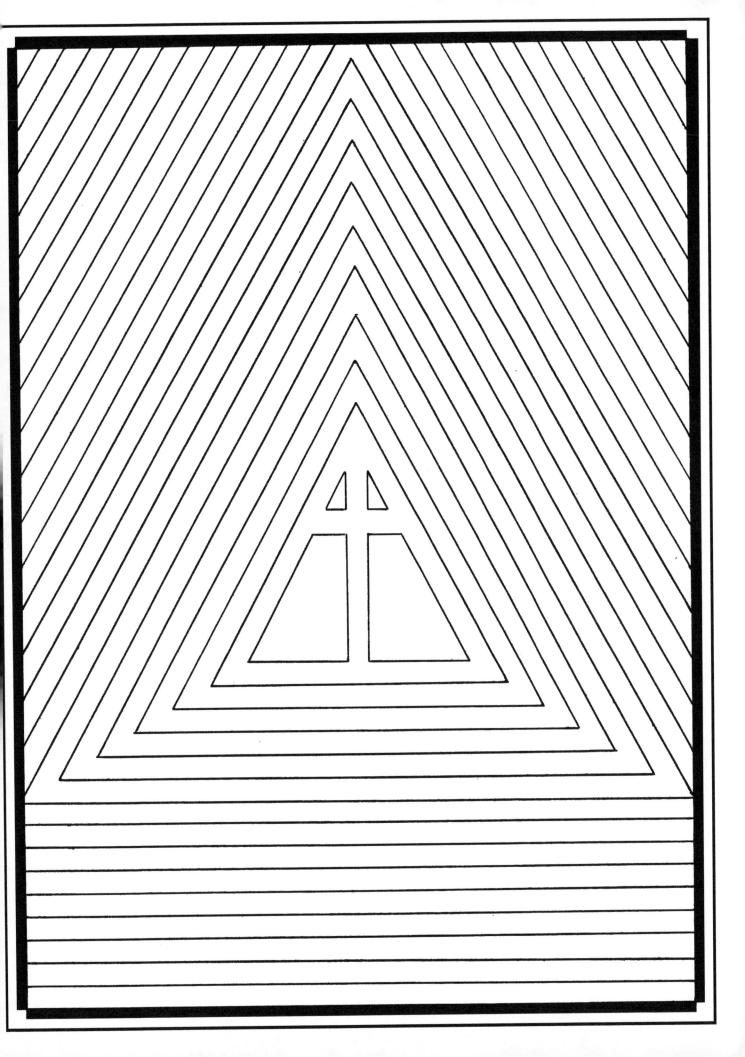

Learn from yesterday, live for today, hope for tomorrow. The important thing is not to stop questioning.

- Albert Einsten

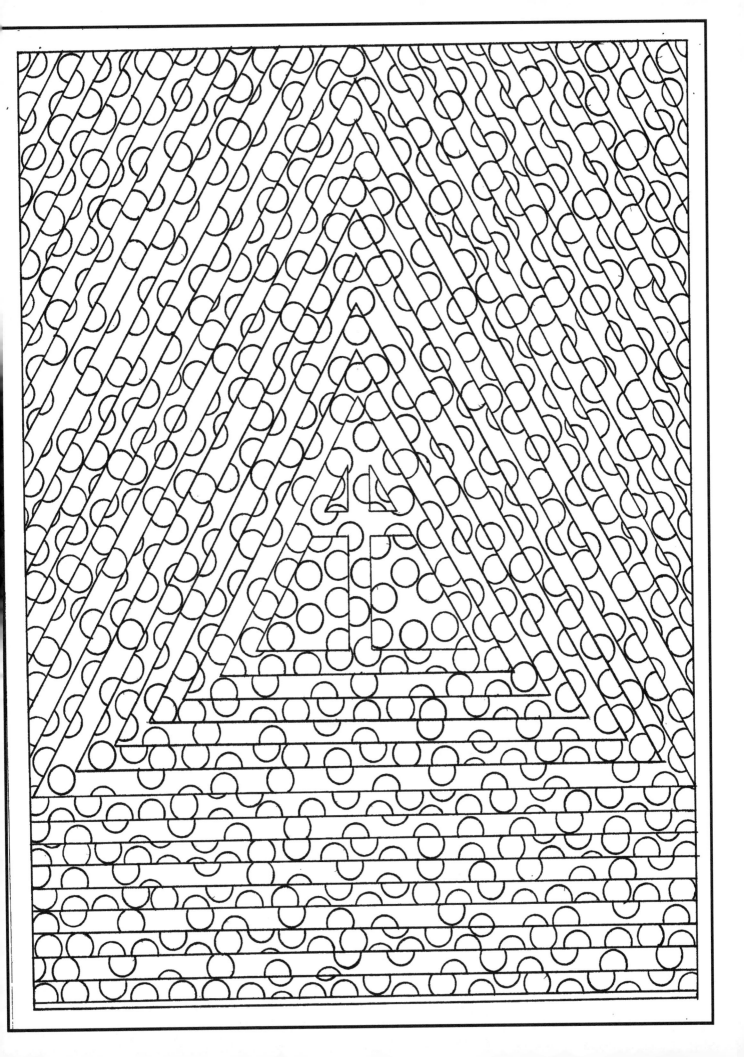

A wise man seeks by music to strengthen his soul: the thoughtless one uses it to stifle his fears.

- Confucius

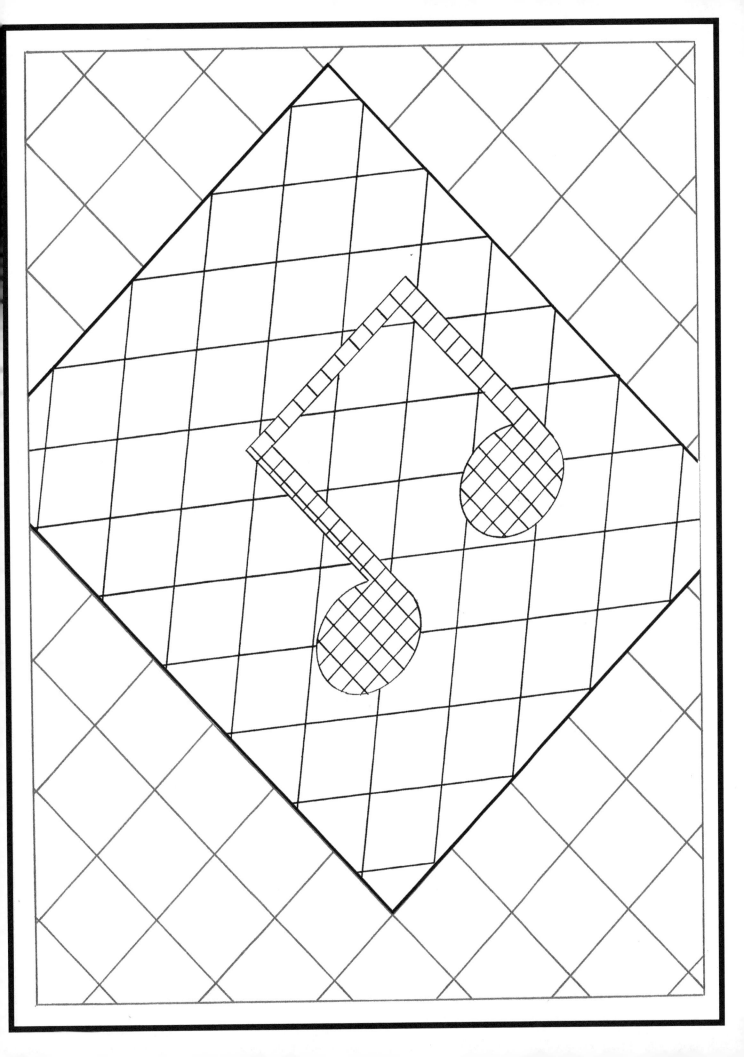

Three grand essentials to happiness in this life are something to do, something to love and something to hope for.

- Joseph Addison

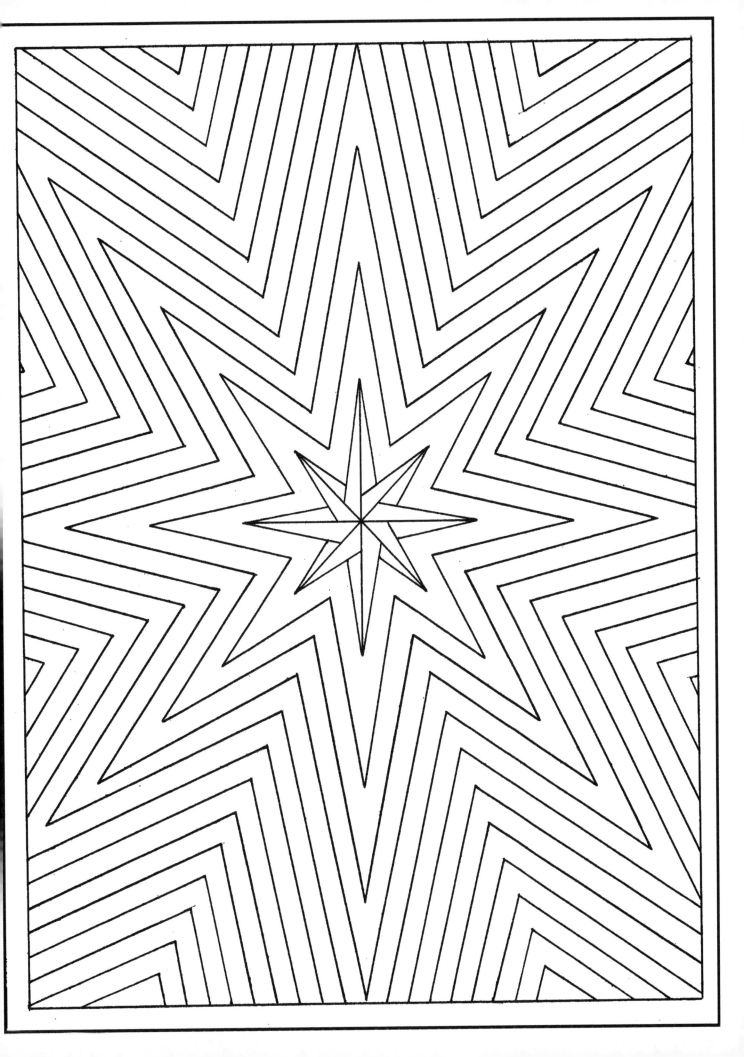

All great things are simple, and many can be expressed in a single word: freedom, justice, honor, duty, mercy, hope.

- Winston Churchill

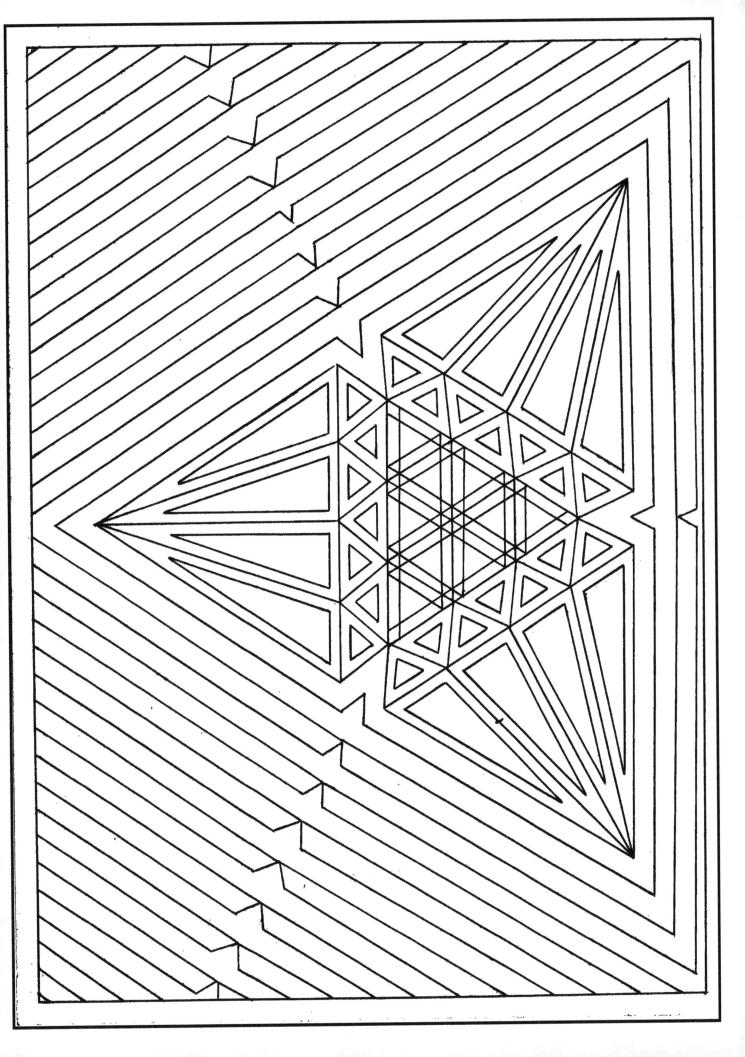

Once you choose hope, anything is possible.

- Christopher Reeve

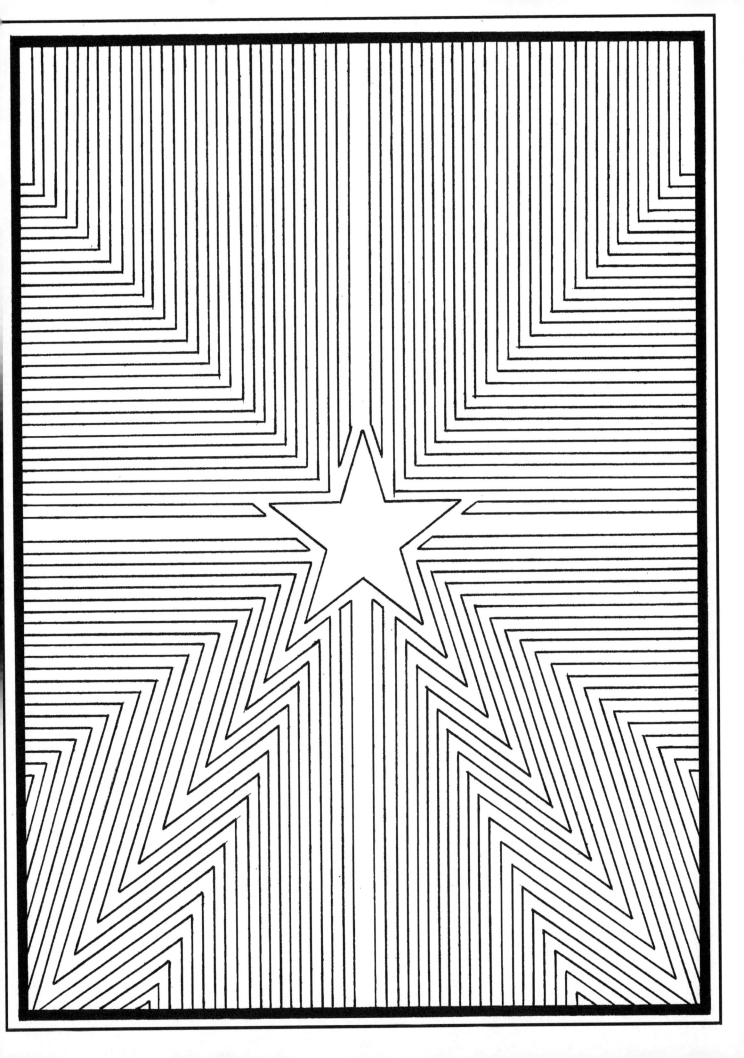

May your choices reflect your hopes, not your fears.

- Nelson Mandela

Where there's hope, there's life. It fills us with fresh courage and makes us strong again.

- Anne Frank

It is because of hope that you suffer. It is through hope that you'll change things.

- Maxime Lagace`

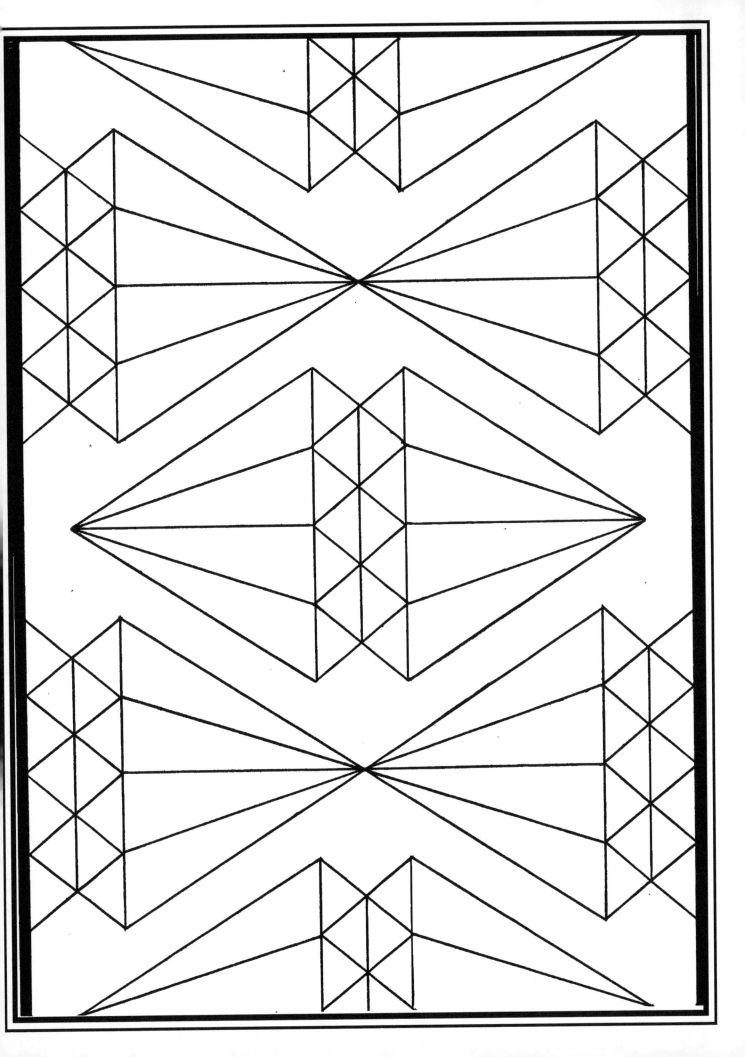

Most of the important things in the world have been accomplished by people who have kept on trying when there seemed to be no hope at all.

- Dale Carnegie

There is no victory without a battle, no testimony without a test and no miracle without an imposssible circumstance.

- Kris Vallotton

Hope sees the invisible. Hope feels the intangible. Hope achieves the impossible. HOPE THOU IN GOD.

- John Hagee

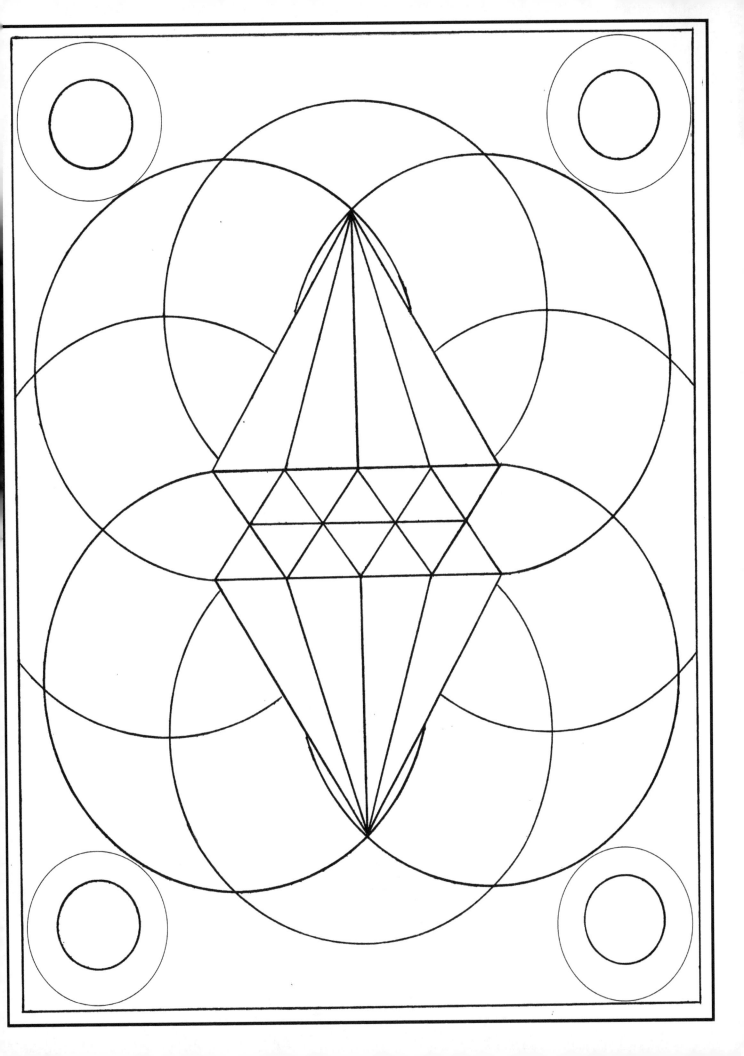

We must accept finite disappointment, but never lose infinite hope.

- Martin Luther King Jr.

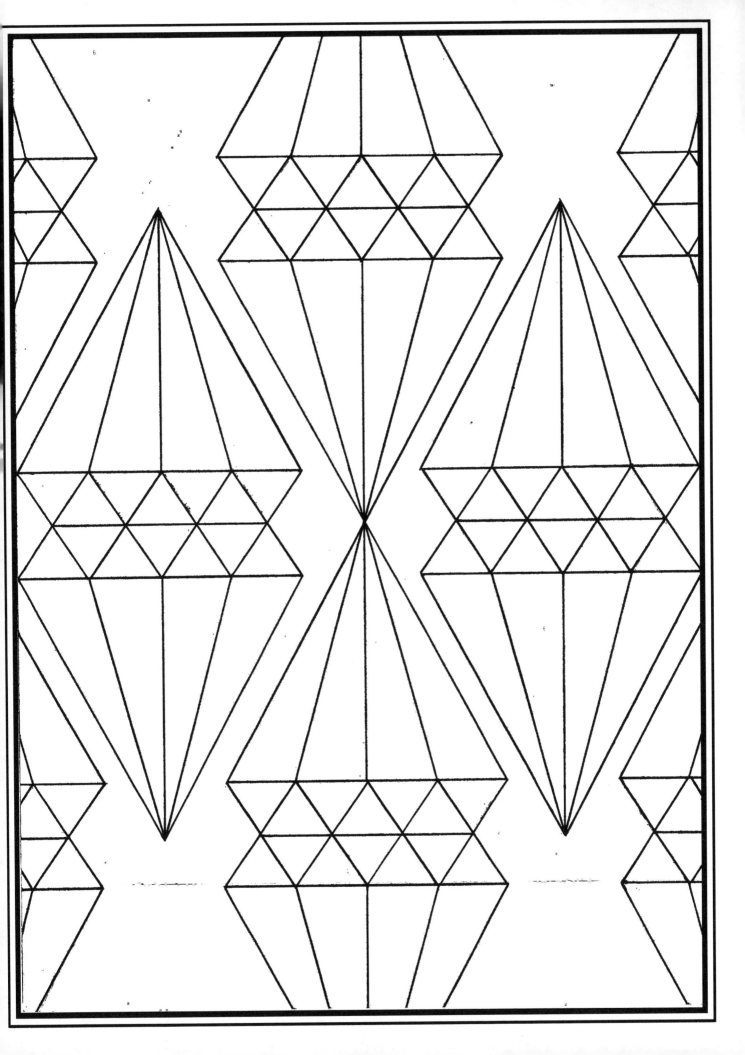

You can suffer the pain of change or suffer remaining the way you are.

- Joyce Meyer

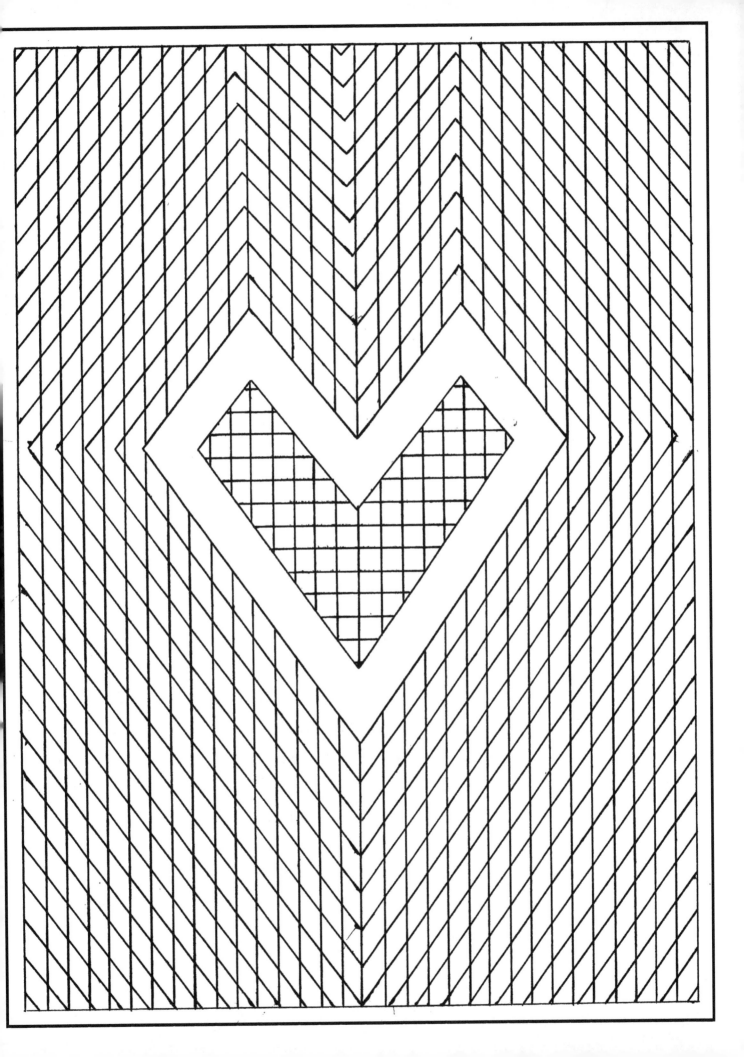

There's nothing noble about being better than your fellow man, true nobility is being better than one's former self.

- The kingsman

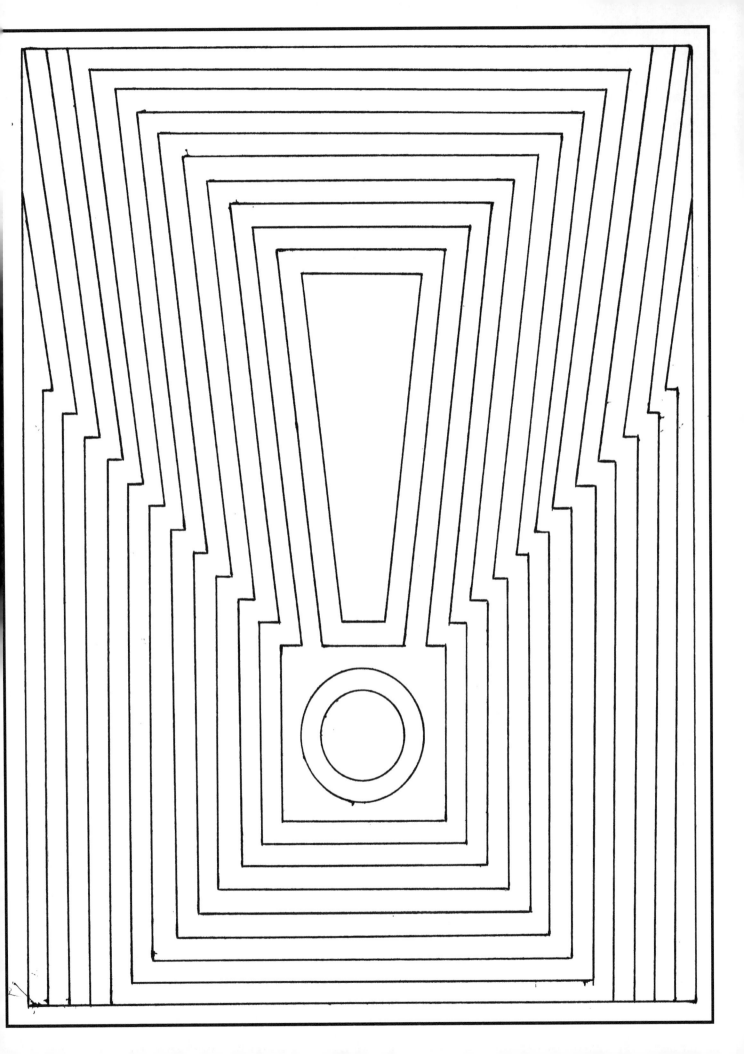

The noble-minded are calm and steady. Little people are forever fussing and fretting.

- Confucius

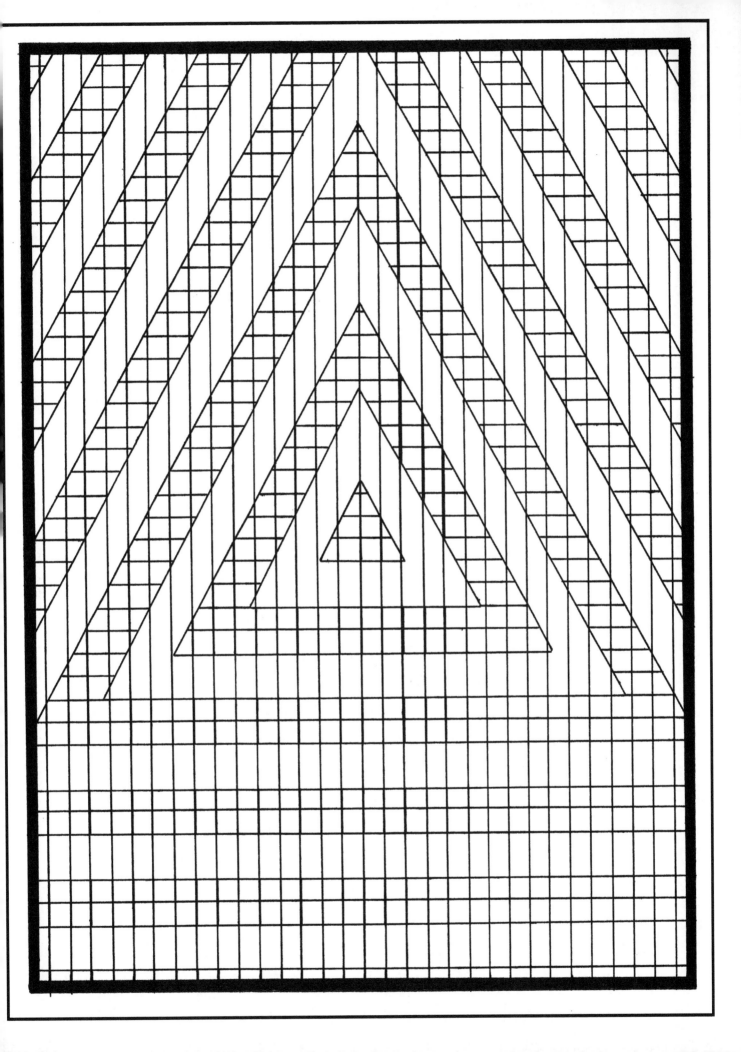

If you don't like who you are and where you are,
don't worry about it because you're not stuck either
with who you are or where you are. You can grow.
You can change. You can be more than you are.

- Zig Ziglar

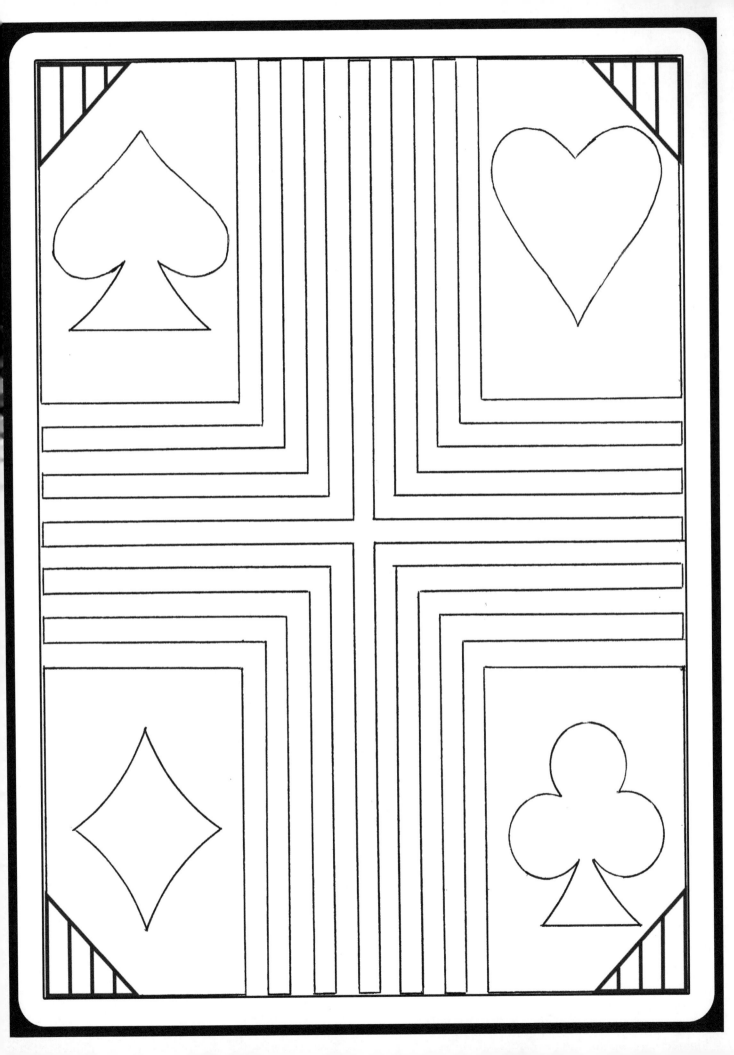

When you close the door of your mind to negative thoughts, the door of opportunity opens to you.

- Napoleon Hill

When we let go of hope, it makes our heart sick. We must never stop hoping. Hope is a tree of life for those who find it.

- Proverbs 13:12 (paraphrased)

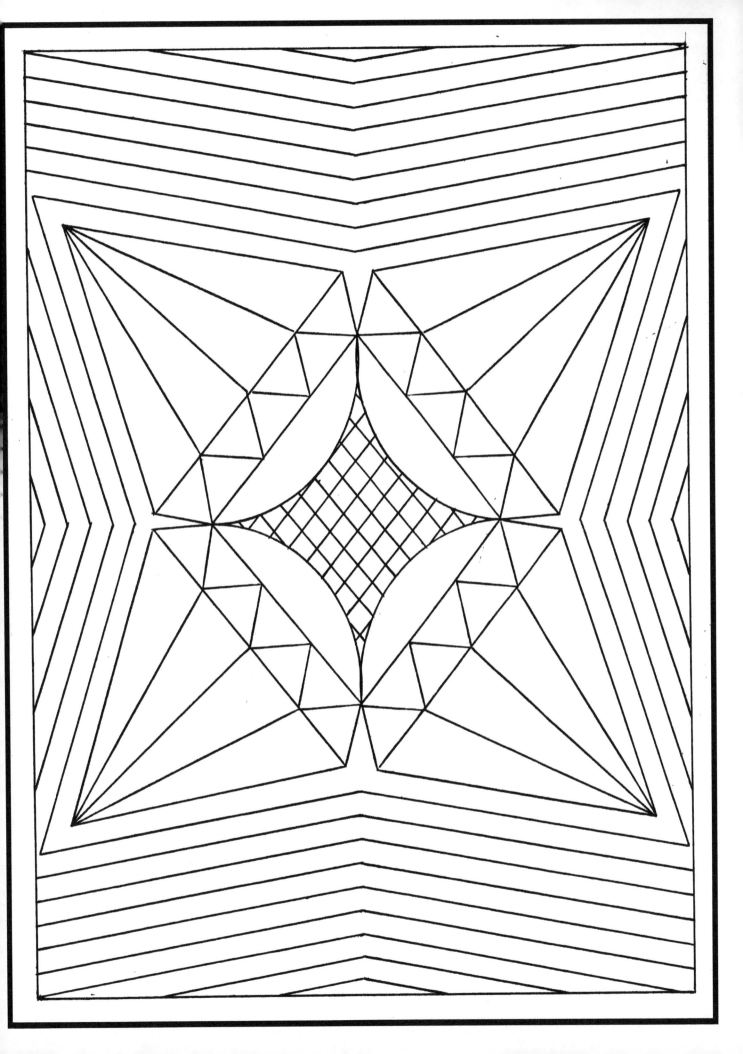

Do not judge me by my success, judge me by how many times I fell down and got back up again.

- Nelson Mandela

Hope is a verb with it's sleeves rolled up.

- David Orr

You will never change your life until you change something you do daily. The secret of your success is found in your daily routine.

- John C. Maxwell

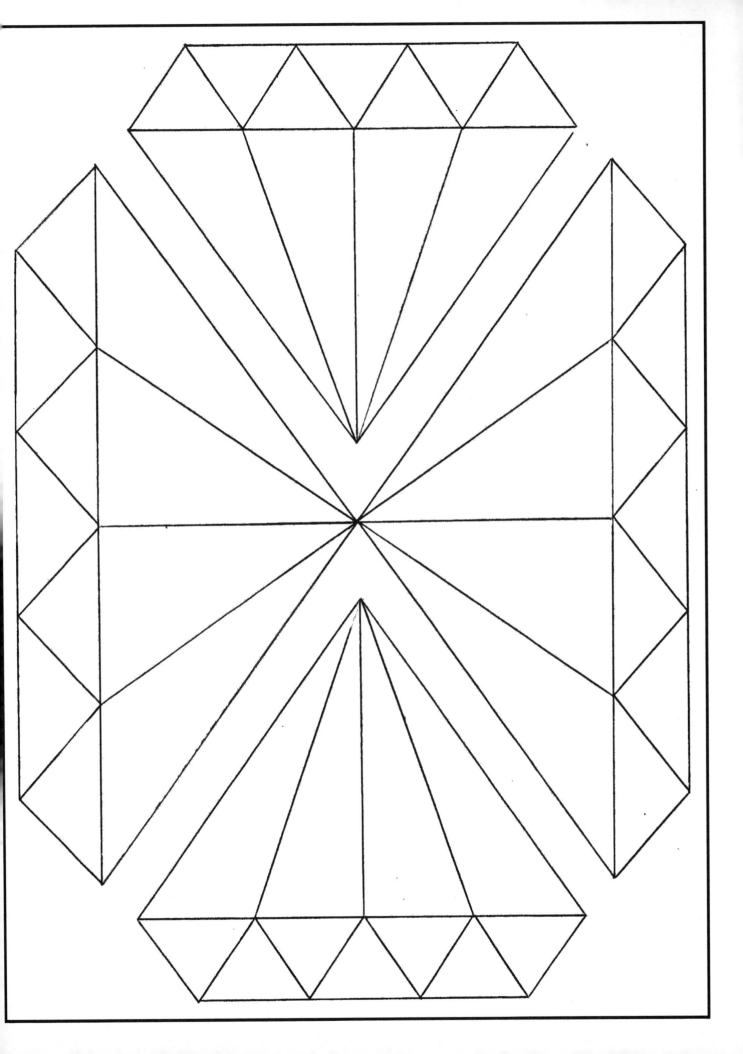

Hope itself is like a star--not to be seen in the sunshine of prosperity, and only to be discovered in the night of adversity.

- Charles Haddon Spurgeon

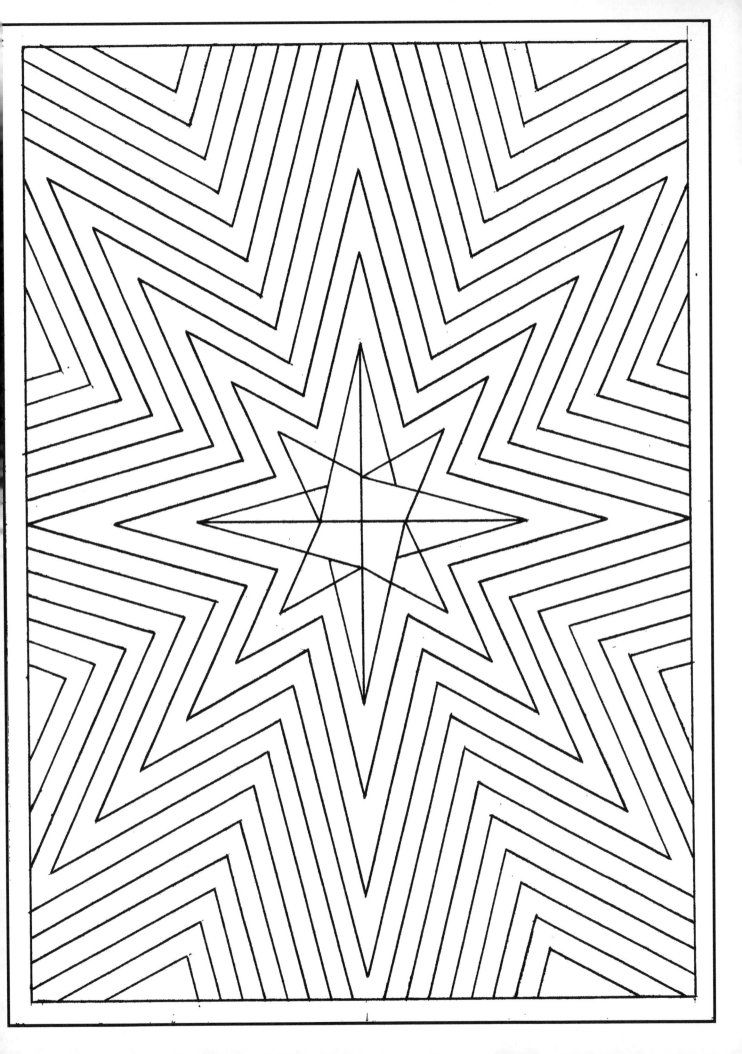

The gem cannot be polished without friction nor man without trials. When you locate good in yourself, approve of it with determination.

- Confucius

Patience, persistence and perspiration make an unbeatable combination for success.

- Napoleon Hill

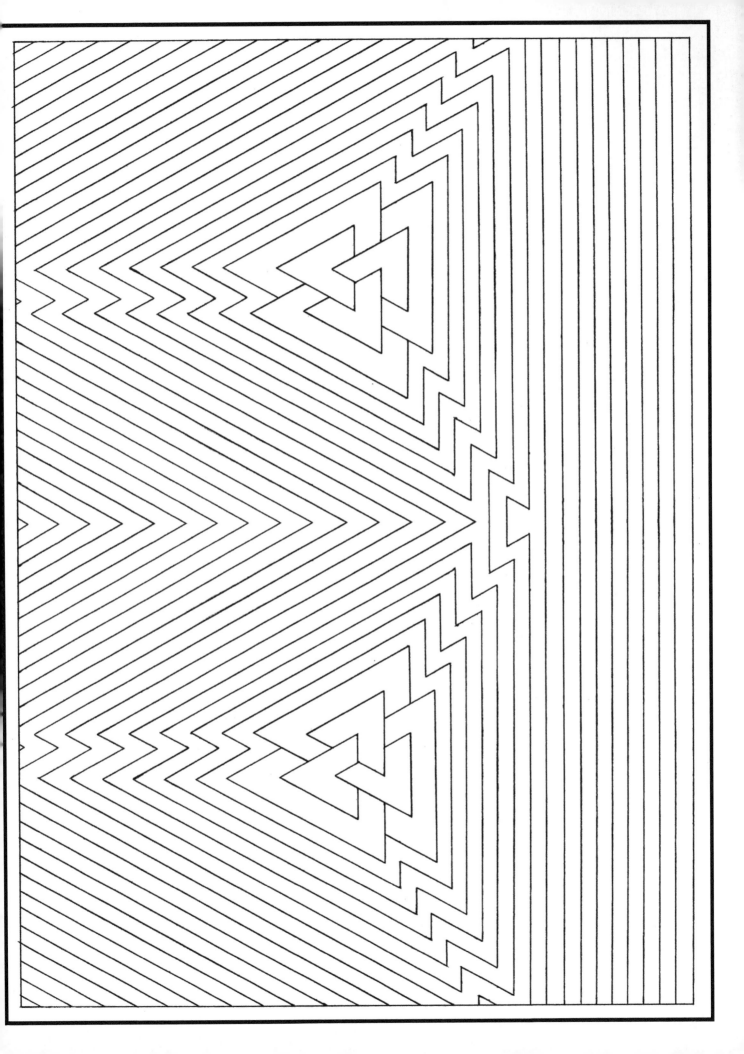

Success is not final, failure is not fatal; it is the courage to continue that counts.

- Winston Churchill

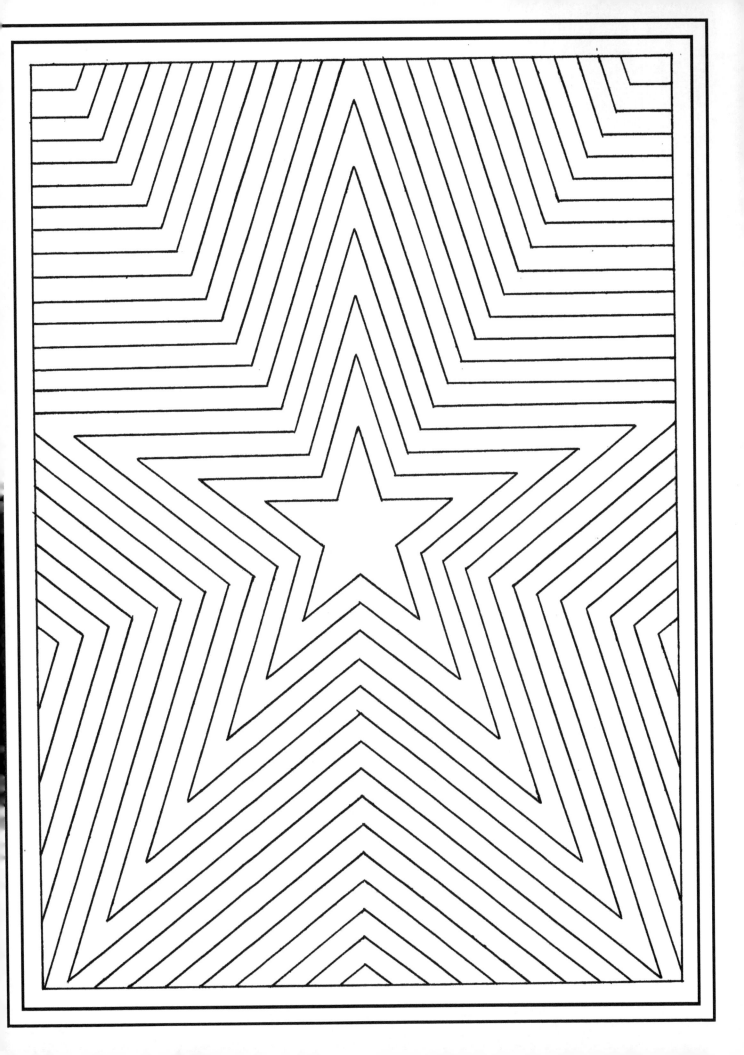

You have absolute control over just one thing, your thoughts. This divine gift is the sole means by which you may control your destiny. If you fail to control your mind, you will control nothing else.

- Napoleon Hill

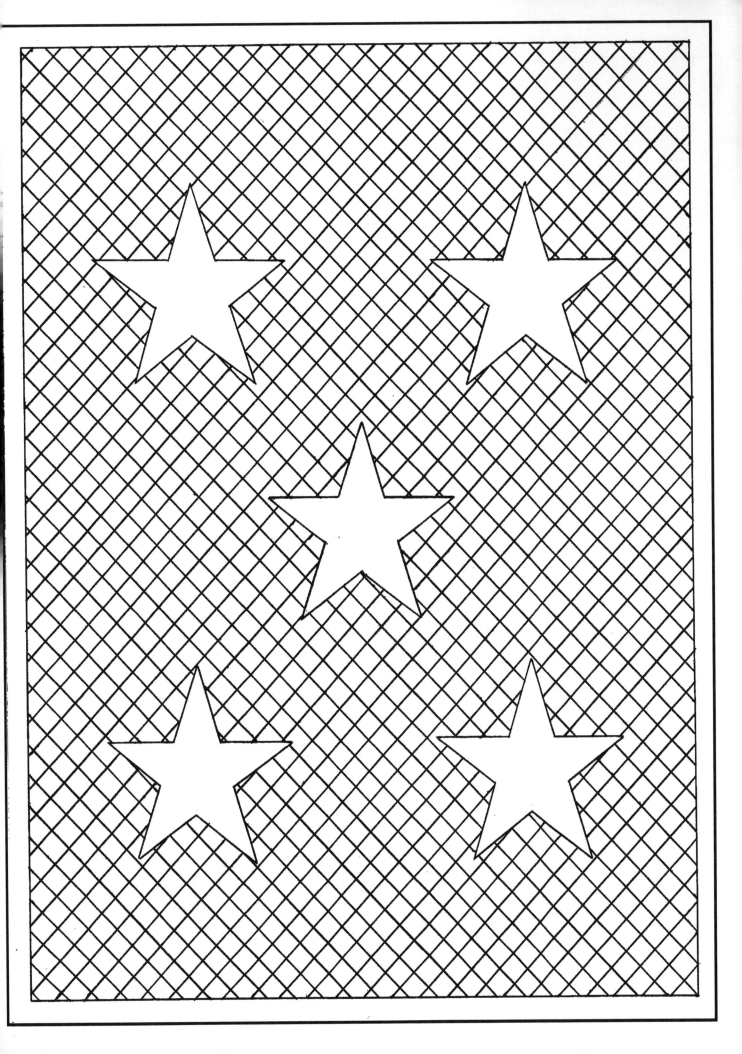

Life is a series of head-on collisions with heartache, suffering, reversal and disappointment. Put on your helmet of hope and hit your problem head on! Your going to be victorious...

- John Hagee

The soul is placed in the body like a rough diamond, and must be polished, or the luster of it will never appear."

- Daniel Defoe

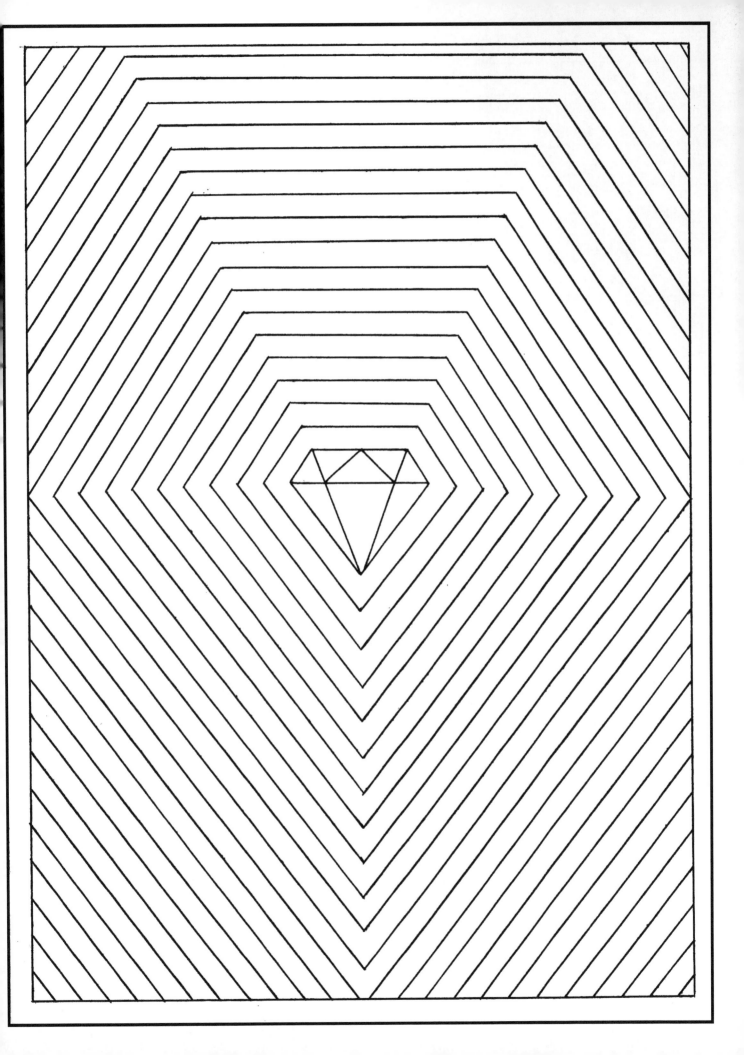

Man was designed for accomplishment, engineered for success, and endowed with the seeds of greatness.

- Zig Ziglar

# OPPORTUNITY!

## Are you a Hope Dealer or would you like to become one?

What is a Hope Dealer? Or, shall we ask, Who is a Hope Dealer... Its me, its you, its anyone who has developed a desire to share the magnificent power of hope through their gifts and talents for the greater good of others.

WOULD YOU LIKE TO HAVE YOUR "READY-TO-COLOR" DRAWING PUBLISHED IN OUR NEXT BOOK?

If you (or someone you may know) would like to share your drawing and your overcomer story (full names will not be used), please send to the address below. Who knows, YOU could be the next Hope Dealer! "It is literally true that you can succeed best and quickest by helping others succeed" - Napoleon Hill.

**SPECIFICATIONS:** Your hand-drawn "ready-to-color" picture should be on an 8.5" x 11" sheet of plain white paper. Please provide contact information along with one paragraph of your Hope Dealer journey on a separate piece of paper. (NOTE: all submitted art becomes property of Hope Dealer Designs and does not guarantee use of all submissions).

*Holly Oden*
Hope Dealer Designs
P.O. Box 35
Mystic, IA 52574

# Mrs. Nationwide 2021

**@ Holly Moorman Oden**

Holly Oden, a native of Centerville, Iowa, enjoys woodworking, DIY building projects, public speaking, creating inspirational videos, and creating Hope Dealer Designs Coloring Books (well, everything). She also enjoys leading the Mystic Youth Group, and teaching/leading at the Mystic Community Church. Holly was chosen as one of Iowa's top 4 "Remarkable Women" in 2020 and had her story featured on WHO Channel 13. She completed a Uganda, Africa Missions trip in 2015 for "Women of Hope" in Kasaroza, and served as director for several years. Holly's latest endeavor is advocating for her platform "Arise Women of Hope" as Mrs. Naionwide 2021 in support of women overcoming life-challenging circumstances. Through this platform Holly is actively promoting the new Circle of Freedom Women's Home in Seymour Iowa (https://www.circleoffreedomiowa.org)

One of Holly's greatest aspirations in life is raising up other Hope Dealers. She personally built a thrift store ministry, The Hope Chest Thrift Store a driving unction, a hammer, and a prayer. From this hope dealing store, proceeds go to provide free counseling services through New Hope Counseling Center & Ministries (newhopeministrycc.org). She has passionately served as the Thrift Store Ministries Director since 2016.

In the community, she volunteers and leads many charitable efforts and fundraisers in support of raising others up which includes the "Back To School Bash" helping to provide free school clothing and supplies for kids every August; "Coats for Kids" (free coat give-away) every October; as well as the "Children's Free Christmas Shopping Extravaganza" every December. She also helps to provide for local housefire victims, and many single working mothers through HAPI (Hope Assistance Program Initiative) extended outreach.

Holly and her husband (of almost 20 yrs), Shawn, live on a farm and have 5 boys; Caleb, Logan, Tiger, Whitton, and Tye. Having grown up with strong, self-motivated, entrepreneur parents (and 10 brothers and sisters), she lives by the motto of "I have not failed, I have found 10,000 ways that do not work".

CPSIA information can be obtained
at www.ICGtesting.com
Printed in the USA
BVHW050829140222
628964BV00015B/533